LIGHT & SHADOW

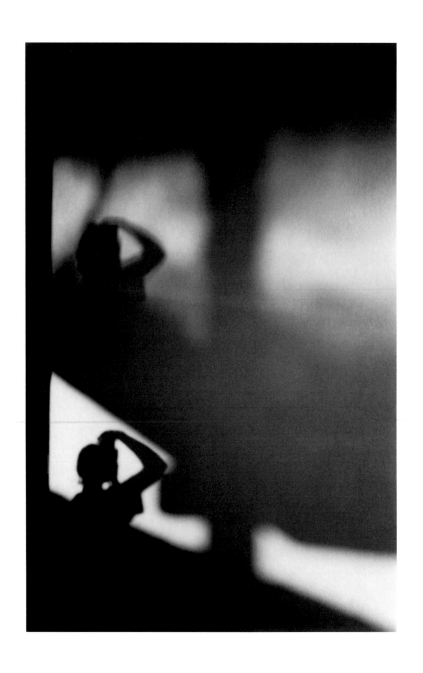

LIGHT & SHADOW

THE PHOTOGRAPHS OF
CLAIRE YAFFA

Foreword by
GORDON PARKS

Poetry by
JEFFERY BEAM

A P E R T U R E

Library of Congress Catalog Card Number: 97-75181
Hardcover ISBN: 0-89381-779-1

DESIGN BY SUSI OBERHELMAN

Printed and bound by Stamperia Valdonega S.R.L., Verona, Italy

The Staff at Aperture for LIGHT & SHADOW is:
Michael E. Hoffman, *Executive Director*
Stevan A. Baron, *Production Director*
Helen Marra, *Production Manager*
Lesley A. Martin, *Editor*

Aperture Foundation publishes a periodical, books, and portfolios of fine photography to communicate with serious photographers and creative people everywhere. A complete catalog is available upon request. Address: 20 East 23rd Street, New York, New York 10010. Phone: (212) 598-4205. Fax: (212) 598-4015. Toll-free: (800) 929-2323.

Aperture Foundation books are distributed internationally through:
CANADA: General Publishing, 30 Lesmill Road, Don Mills, Ontario, M3B 2T6. Fax: (416) 445-5991. UNITED KINGDOM, SCANDANAVIA, AND CONTINENTAL EUROPE : Robert Hale, Ltd., Clerkenwell House, 45-47 Clerkenwell Green, London EC1R 0HT. Fax: 171-490-4958. NETHERLANDS: Nilsson & Lamm, BV, Pampuslaan 212-214, P.O. Box 195, 1382 JS Weesp, Netherlands. Fax: 31-294-415054.

For international magazine subscription orders for the periodical *Aperture*, contact Aperture International Subscription Service, P.O. Box 14, Harold Hill, Romford, RM3 8EQ, England. Fax: 1-708-372-046. One year: $50.00. Price subject to change.

To subscribe to the periodical *Aperture* in the U.S.A. write Aperture, P.O. Box 3000, Denville, NJ 07834. Tel: 1-800-783-4903. One year: $40.00. Two years: $66.00.

FIRST EDITION

10 9 8 7 6 5 4 3 2 1

FOR MY HUSBAND AND CHILDREN
WITH LOVE

THE WORLD OF
CLAIRE YAFFA

BY GORDON PARKS

LIGHT, THAT ETERNAL MYSTERY, will always baffle the eye and soul. Claire Yaffa, searching for herself within the edges of it, moves cautiously into a realm of discovery that escapes most of us. For at times light is evasive, for photographers and painters alike; hiding within light, blanketing shadows grope for their own existence. In the silence, her eye roams on, exploring deserted areas bitten out by the teeth of space. Then suddenly, what were only empty moments before, are filled by imagery that flames into her imagination—the haunting curvature of an arm, or perhaps a hand, a thigh like a river flowing. Whatever appears seems to have been carved from grace.

Undoubtedly Claire Yaffa sees such imagery from the windows of her imagination—one that seems to pace restlessly during her thought-laden hours. Don't question her about those images. She doesn't always

know how they come to haunt her. It is as though she swims in a fog, searching out that mystery lurking in light and shadow. When ideas claim her she takes her bearings and starts to work. For her, waiting is time wasted.

Better perhaps that she doesn't question herself about her pursuit. The arresting results are far more important than what she remembers or fails to remember about each experience. The wonderful thing about these beautiful images is the joy they bring to her and to others. Certainly they keep her heart in the future—and with a hunger that keeps her going. At times she readily admits to being confused about her existence within her photographs: "Often I find it difficult to summon the real me. I only know that I am there somewhere and that I musn't disappear. While the exposures are taking place I am far away, in another world it seems. When reality returns I discover parts of myself strangely afloat in what was once empty space."

Bit by bit, in her world of light and shadow, Claire Yaffa has come to know it in her own way—carefully feeling out its mystery with eyes and heart wide open. While a part of her lies waiting to enter its changing perimeters, that deserted space keeps yawning. Awed, she carefully looks for a way to fill it with the solitude of herself. When that self, light, and shadow eventually come together they are like different horizons touching—profoundly and softly speaking Claire Yaffa's kind of poetry. □

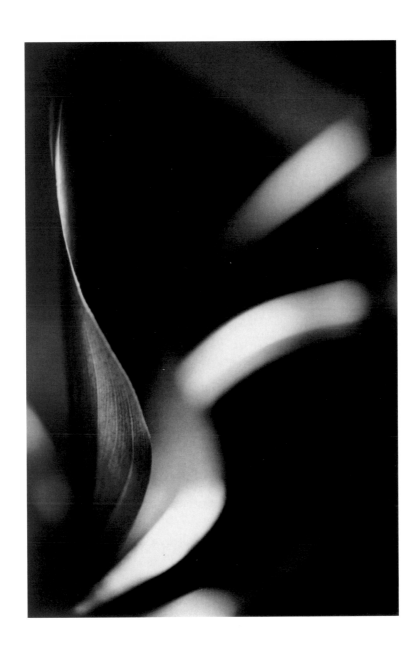

BEAUTIFUL BEAUTIFUL LIFE

with what has been and has not been me asking to

become part of something it has not seen and seeing

it part of me within it part asking to understand

and understanding again its silverness its part which

shines and the dull the whole beneath the inside

and lightning lightning no not fleece but unbearable

seeing which knows O knows so seeing inside

beautiful life beautiful life asking of nothing asking

—from *Submergences*

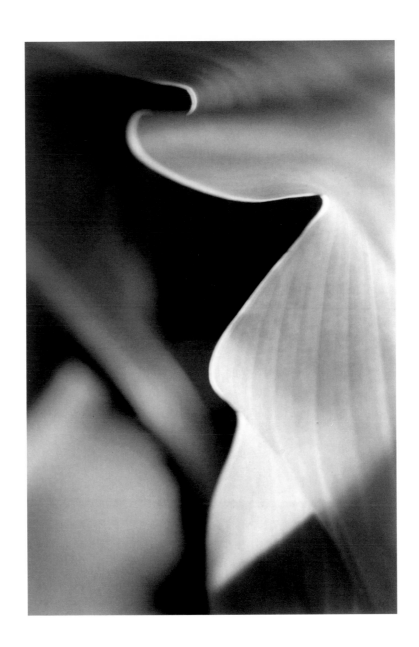

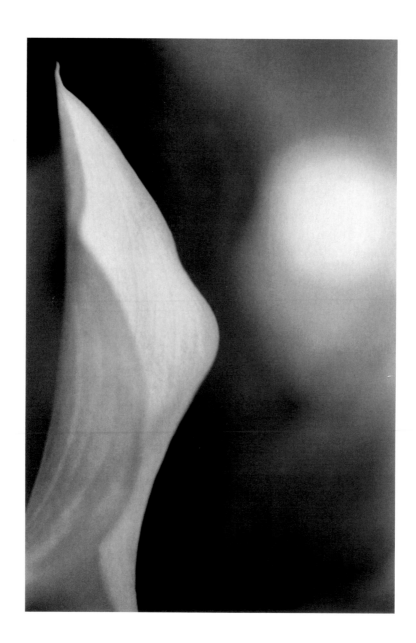

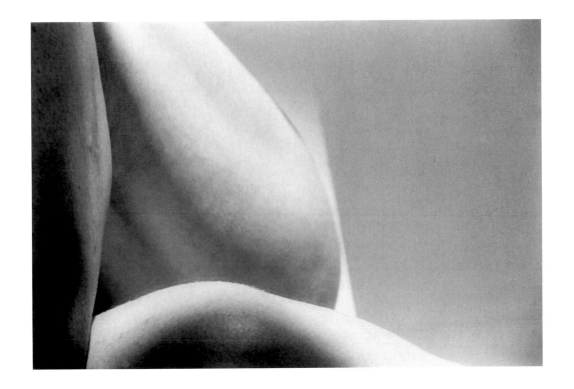

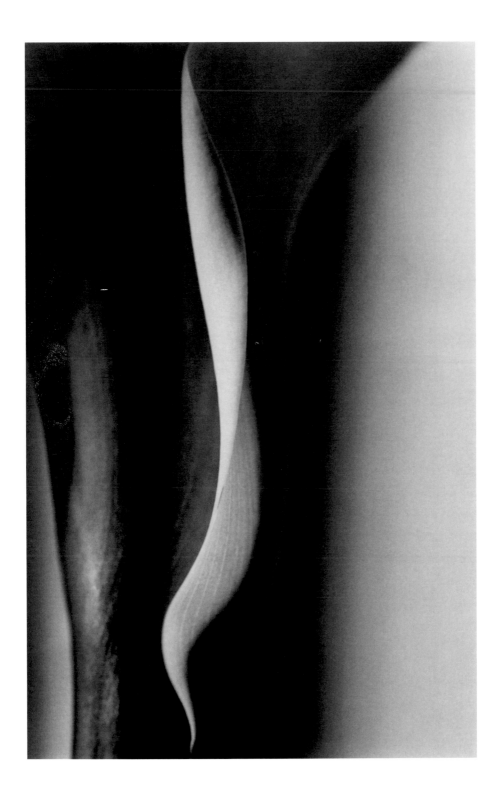

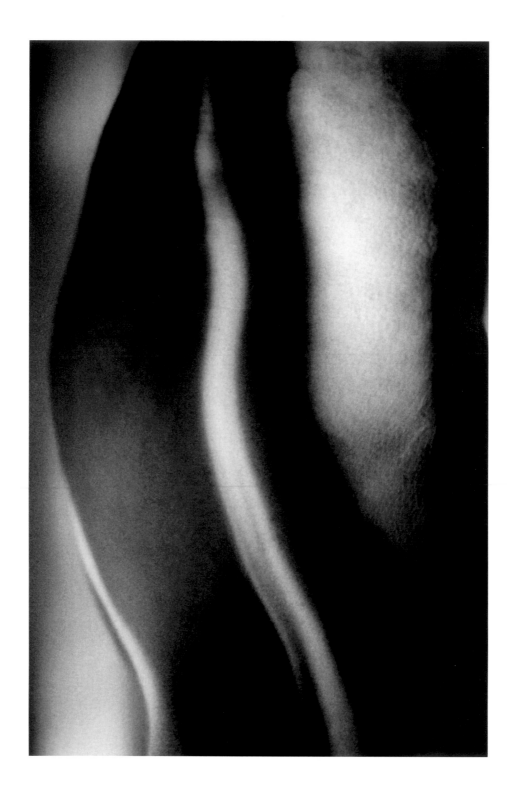

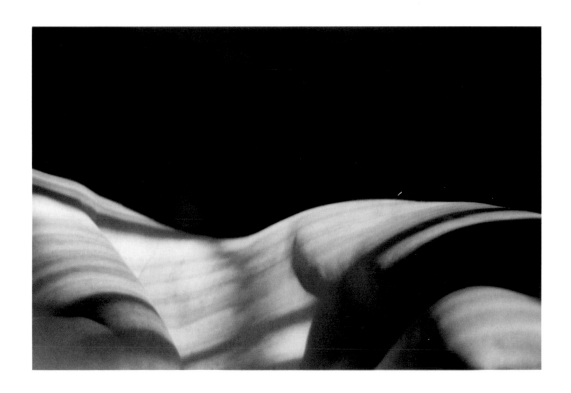

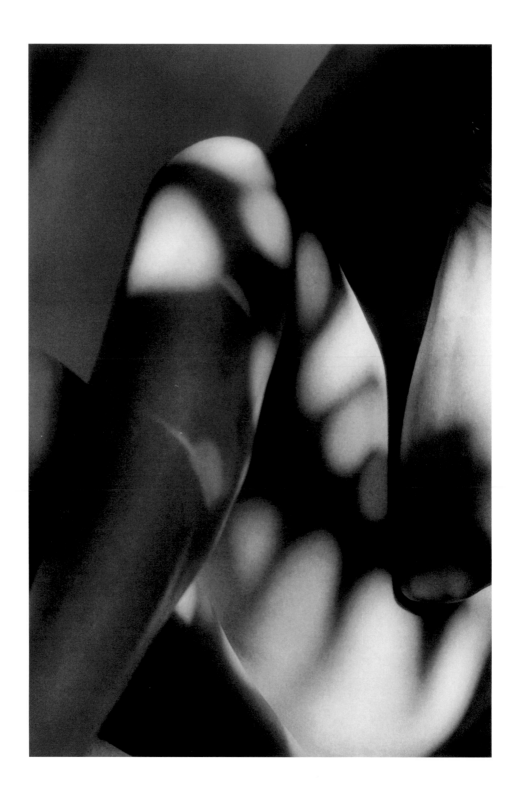

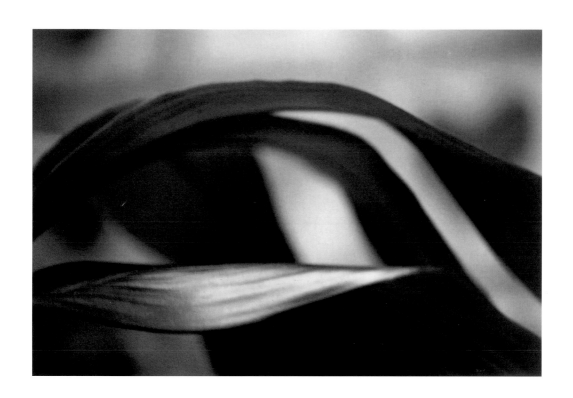

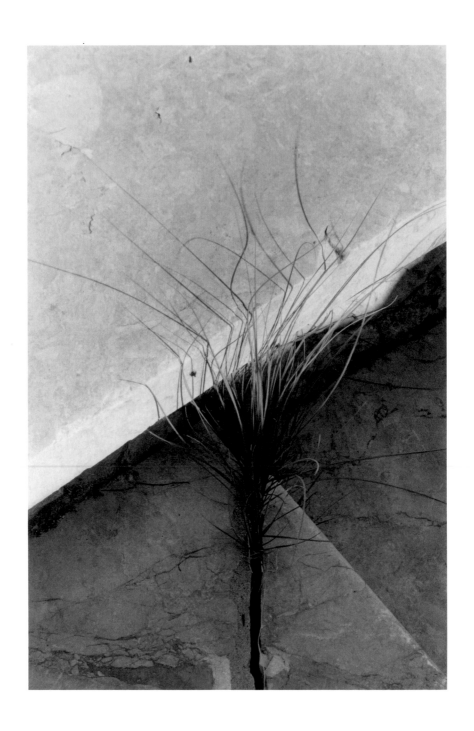

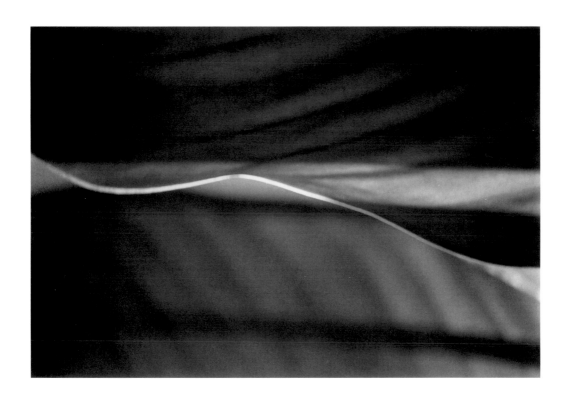

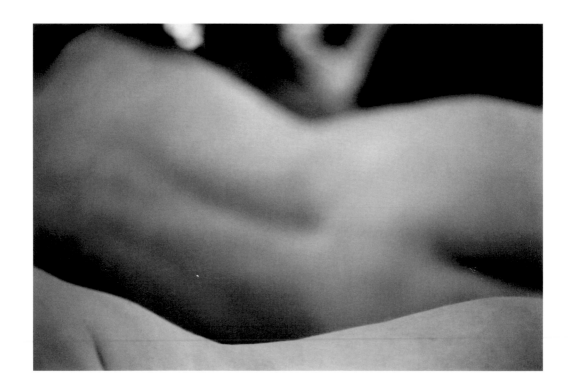

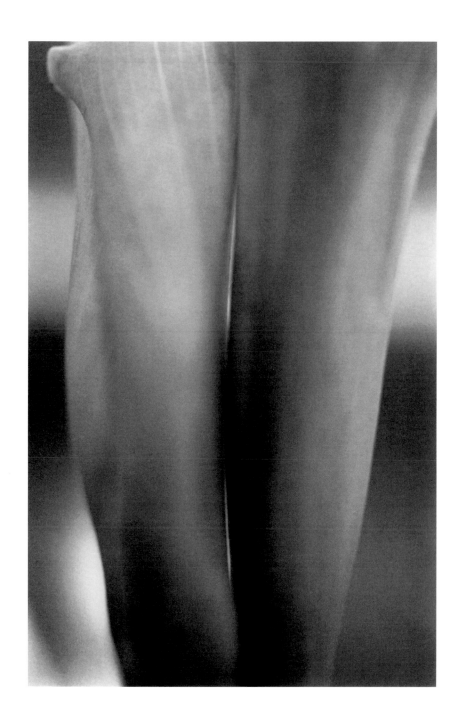

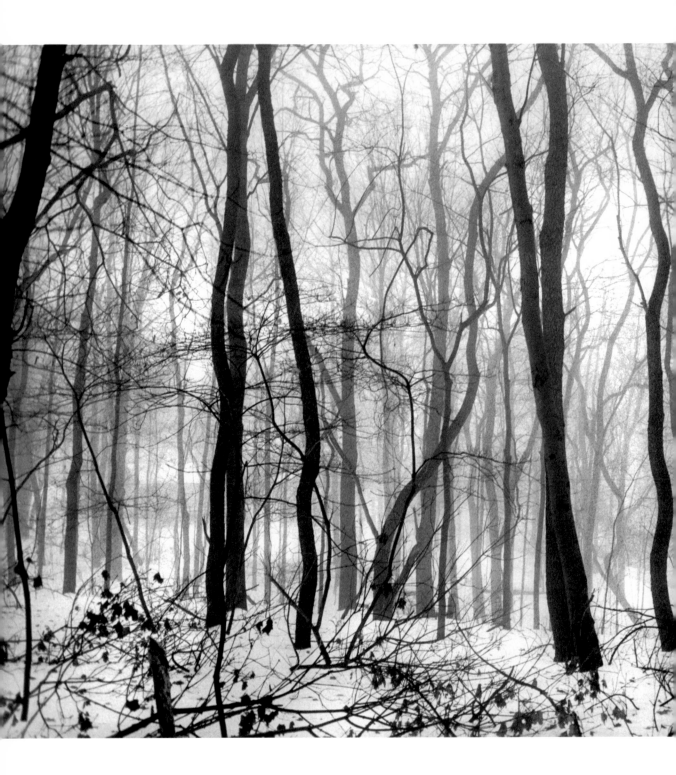

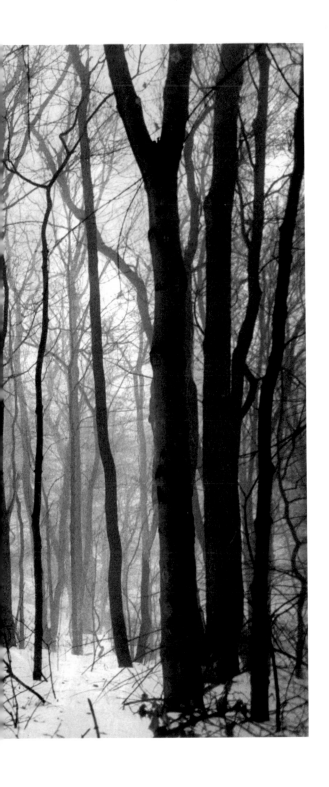

THE BROKEN FLOWER

for Alexander Gilmore III

That a broken flower
could speak or

a bird's feather
found forlornly on the path

tell symbols
amazes us.

The last place we would think
to look

there in the discarded
shattered world.

The petals no
less lovely still sing

a loving intention.
The feather a floating

memory forever lightened
by its past.

The hand which carries them
the way humans can

when that which is broken or
displaced is made repaired,

renewed. Rediscovered:
the most perfect flower the most

perfect feather.
That the flower

has no stem only
confirms it.

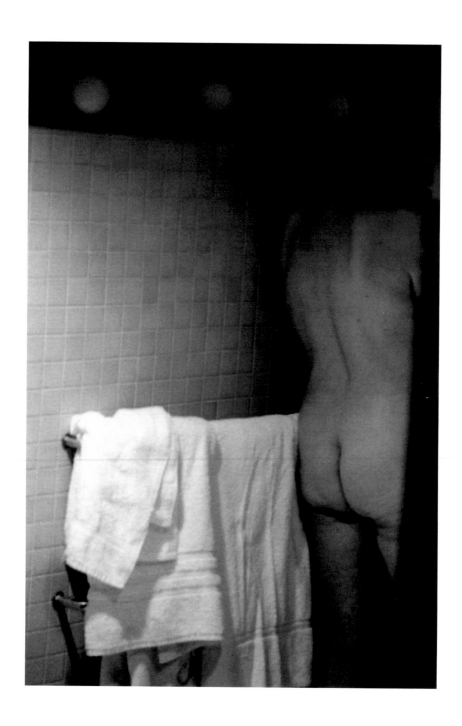

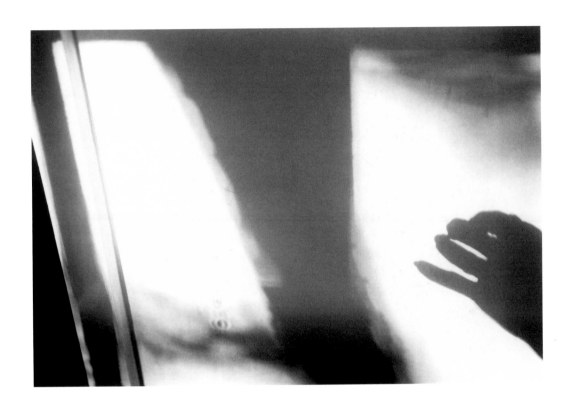

People say
 we should not linger
with grief
 but bind
instead the bruise
with the future's
 sweet petals

I can't deny that grief's
tentacles
are marine
 carnivorous
but
 in deepest oceans
 fish
variegate their own lanterns

The amaryllis
 a flower
I have called before
takes to the dark
with vengeance
 multiplying
scarlet trumpets
when the sun
fills
 finally the kitchen

My God, we leave
behind so much
to gain a little

When
 to go forward
we should only have to
 strike
 a stone for fire
in the wine
cool darkness

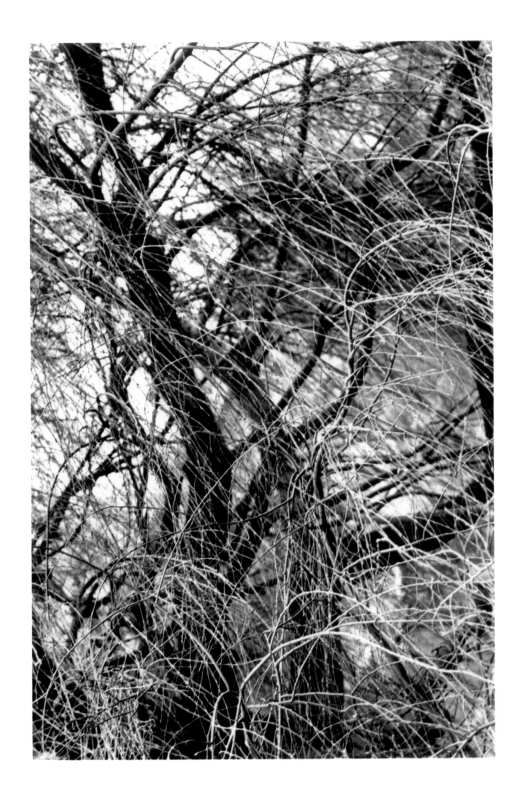

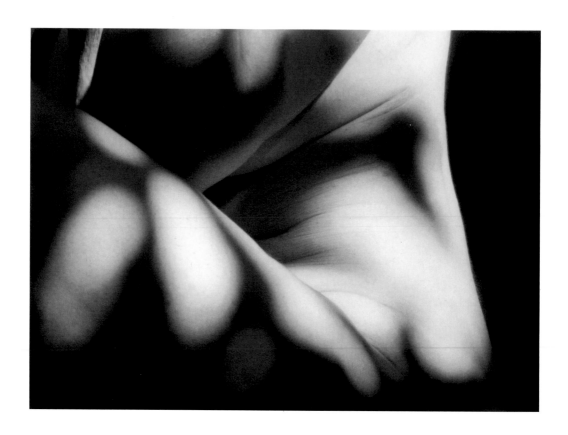

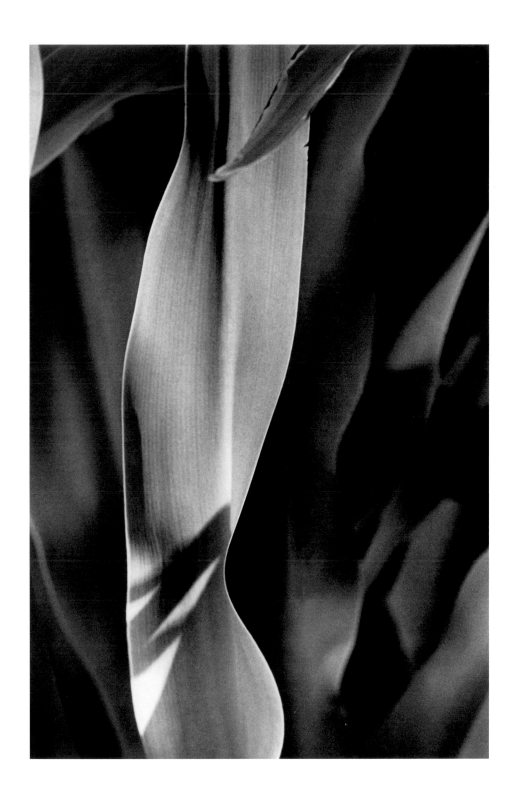

A COMMON FLOWER

The chysanthemum is
not so pink
nor so dark
as royal badges,
formal and obtuse.

Its pinkness
terrifies
as when a lamp
illuminates your palm

and a yellow glow
vibrates
through the center—
a greenness in that.

The eye
germinates in the green
honeycomb
swirling middle.

You must
bring sorrow into
clearer focus
before it.

In any house—
in this one—
shadows are not
fearsome,

but the privilege of light,
constantly visible,
where beauty
lies with

its pink
heart
severed and
slowly drowning
is.

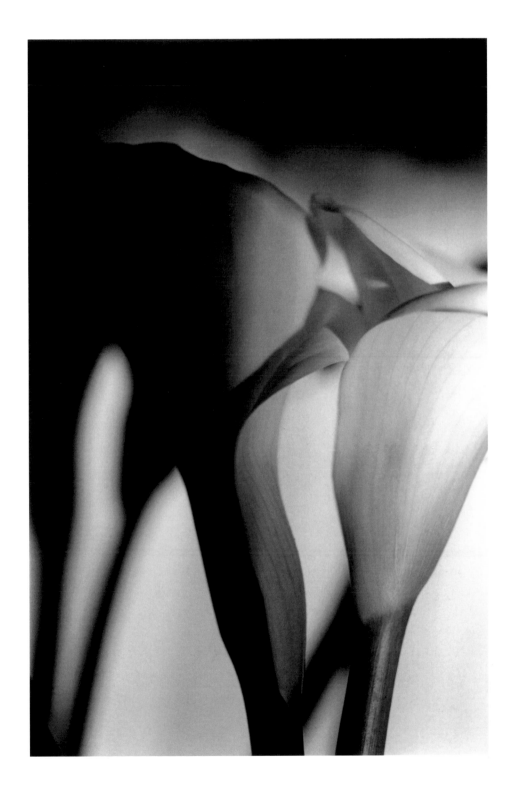

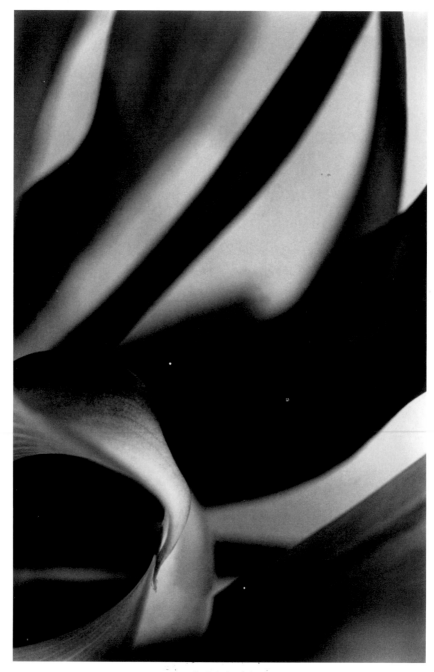

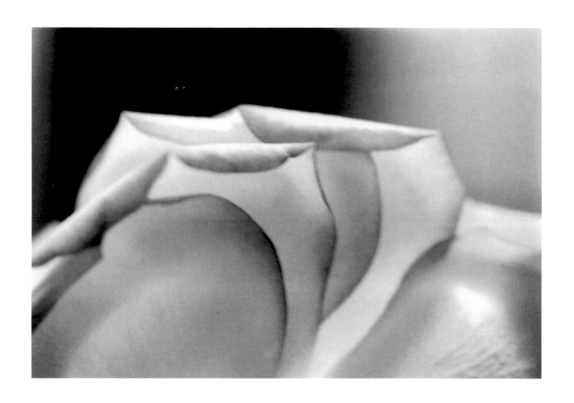

THERE

Let the fog
awakening us each day be
a start.
And the stars
in their cleverness
please you.

Stones
bound together by moss
and years are
no more clever, nor
the stars, than your
steadfastness.

Such is the foolishness
of men
who would not know
love,
they would turn
deaf

to the challenge.
As for me,
I did not ask to
enter the needle's
eye.
The painted turtle

in the long light
of ponds
can go through.
But not me, I said.
And yet,
I find myself

there.

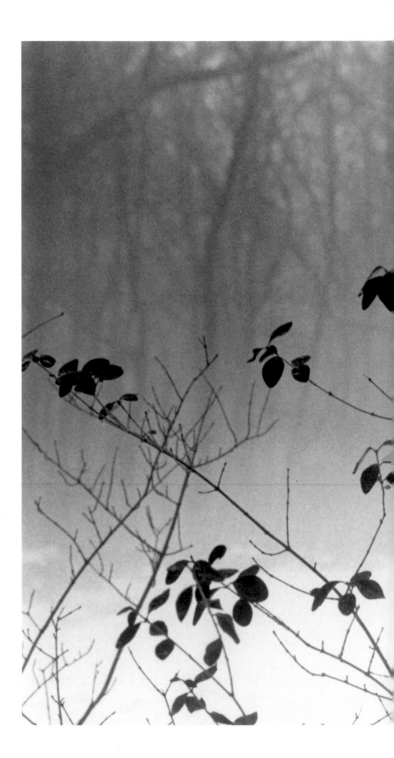

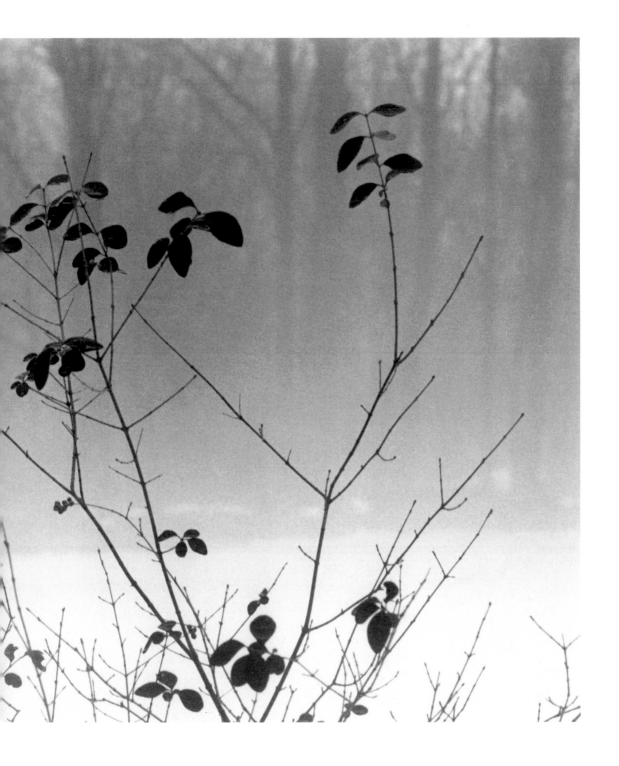

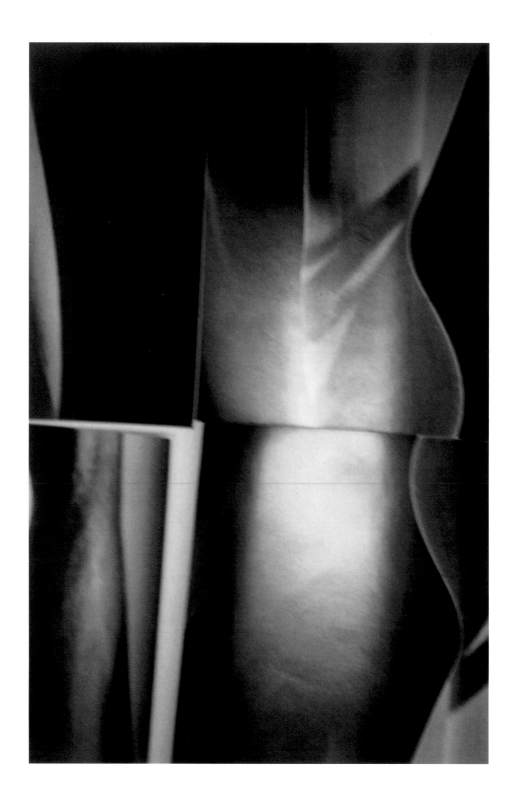

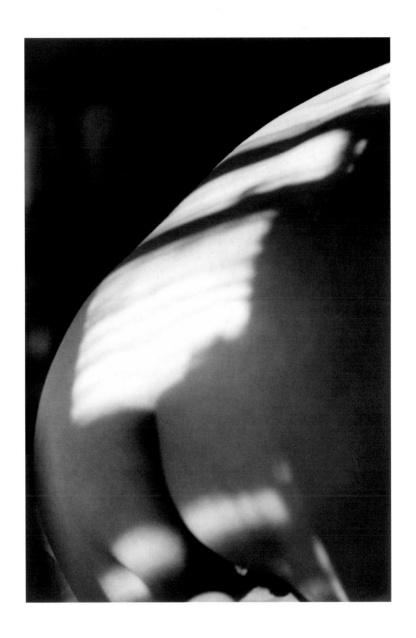

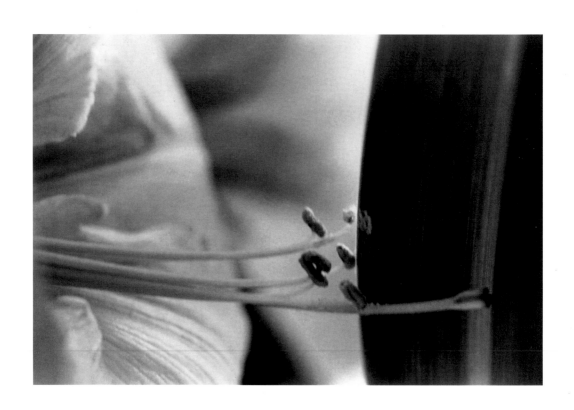

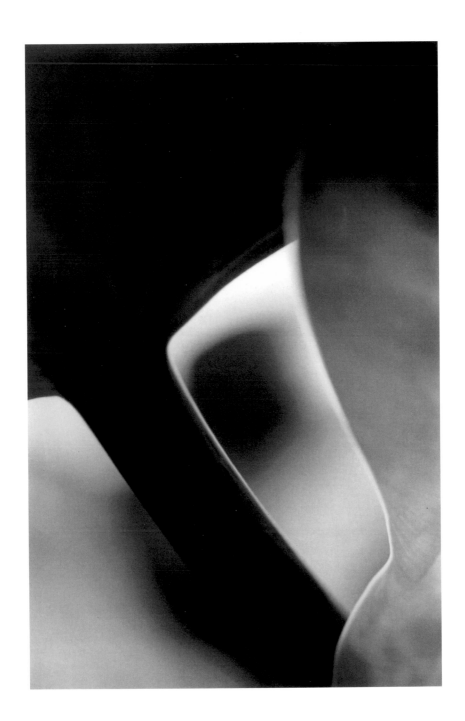

YOU TELL THE STORY OF

your emotions. I do not know you, you say.

I cannot know you. The you I see is not the you

which is you. The you which you have known

for your lifetime. The you I see is the you of Now.

What is your Now, is yourself, transforming. We

live in a mirror. I see your reflection in my own.

Never ourselves but what we see in each other.

The mirror's white teeth creating images of hand-

to-hand the laid-back motion of our bodies.

—from *Submergences*

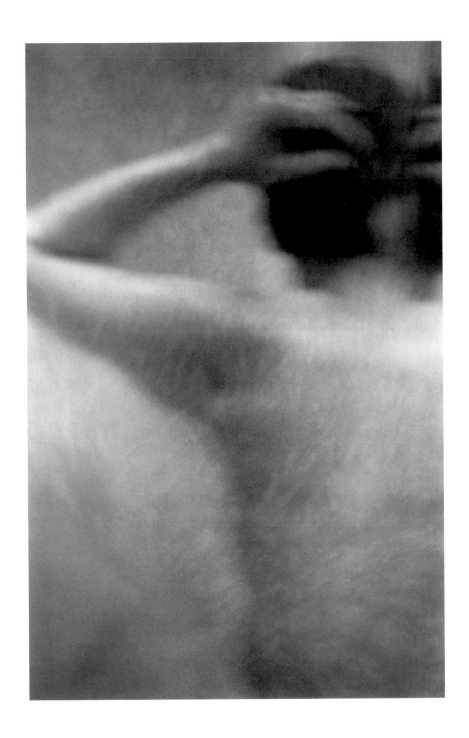

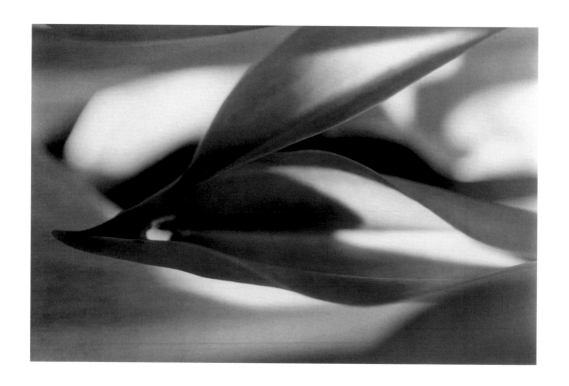

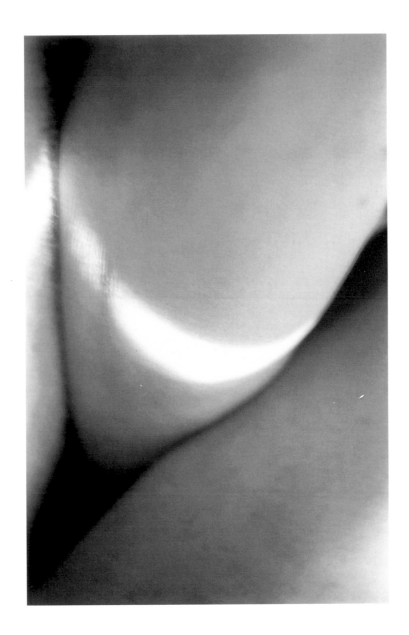

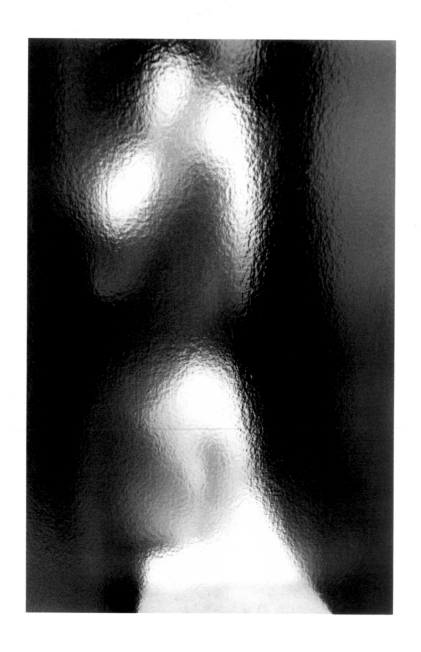

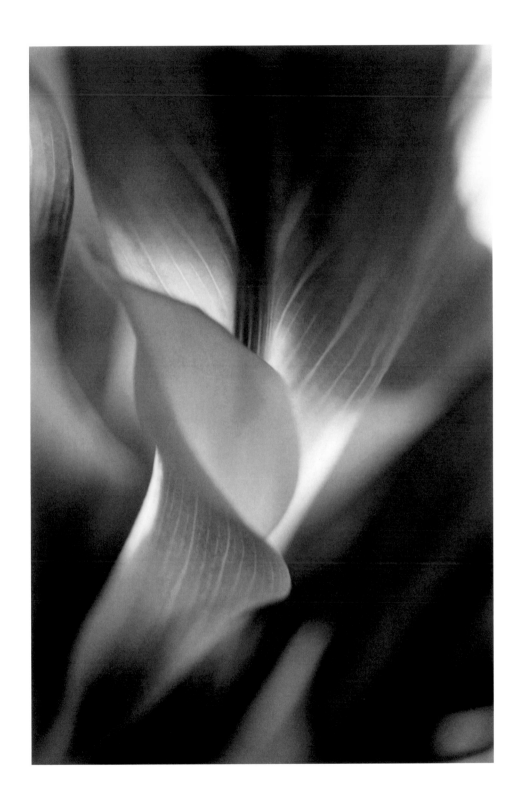

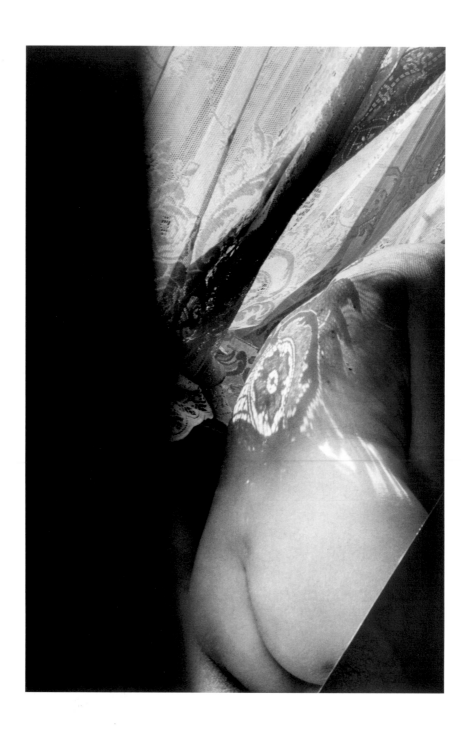

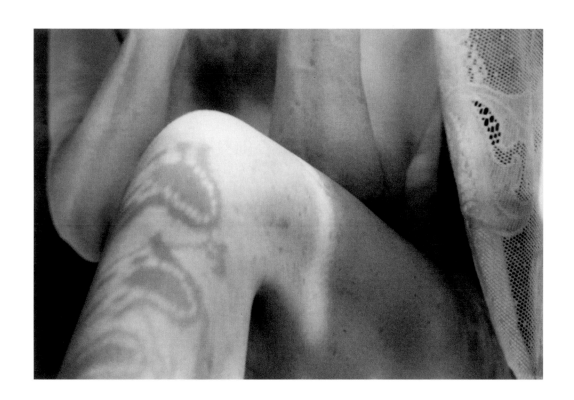

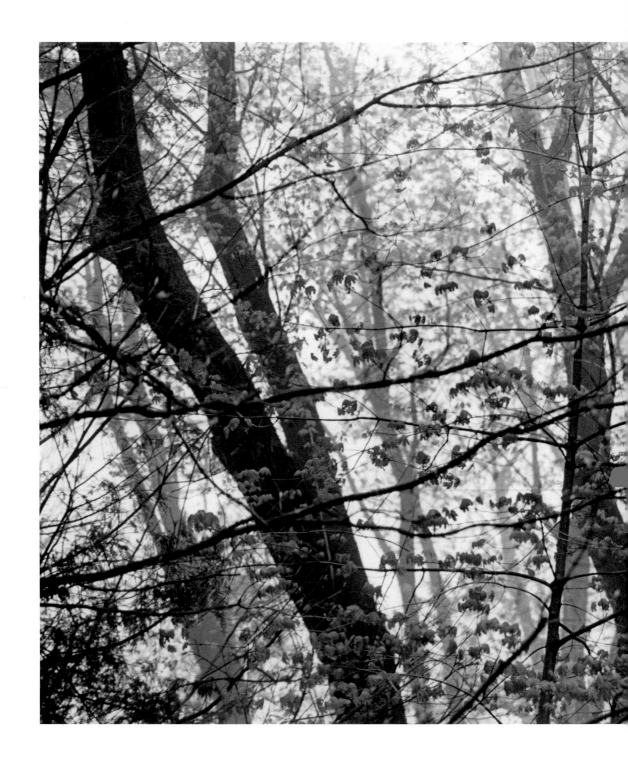

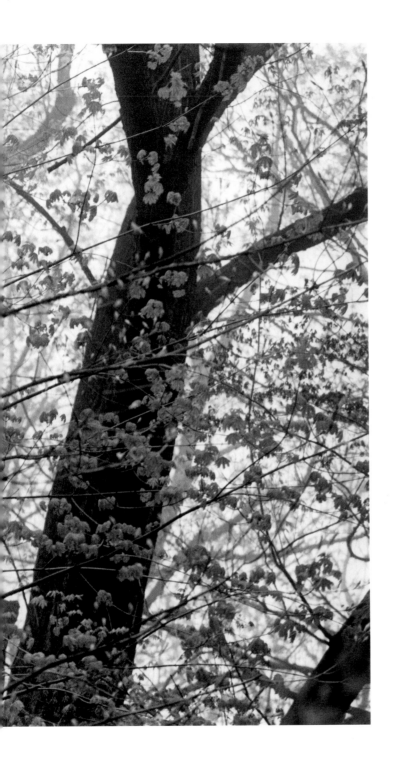

WHEN

the daffodil is high
the first time
Spring arrives
in time

Nothing marks the change
so well as Time's
demise in
Winter's night time

The spider busies
itself
for the throwing
open
of windows

MADRIGAL

I will love you with
hands of gentians
so the warmth of your skin
will be the warmth of
apples ripened
The red of
summer clover

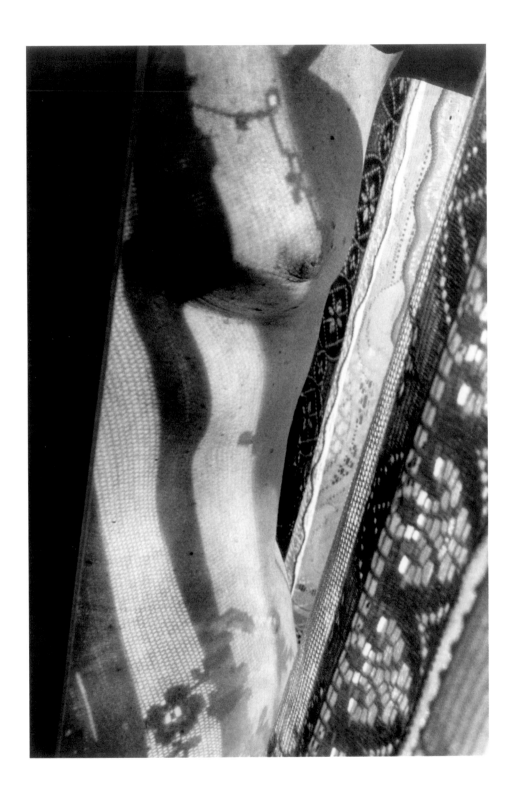

IN PROVENCE

for Jack Fullilove & Alain LeSage

After miles of bare trees
and cypresses

what's this

a spindly shock
canary yellow

A tree twelve feet tall
grappling out
of a walled garden

Leaves
 flames
citron-colored

The world keeping
secrets from me
and then
this

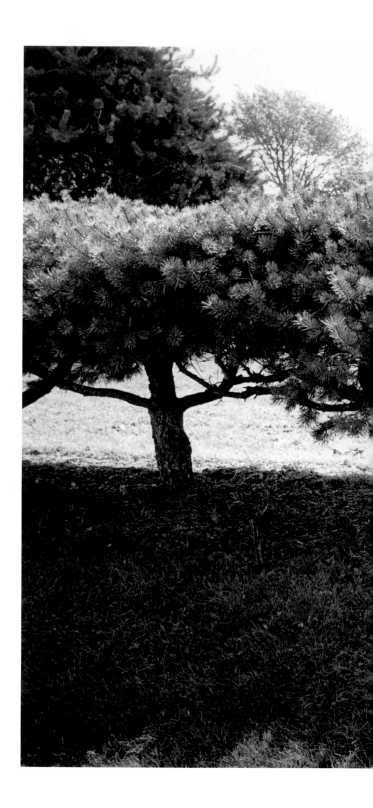

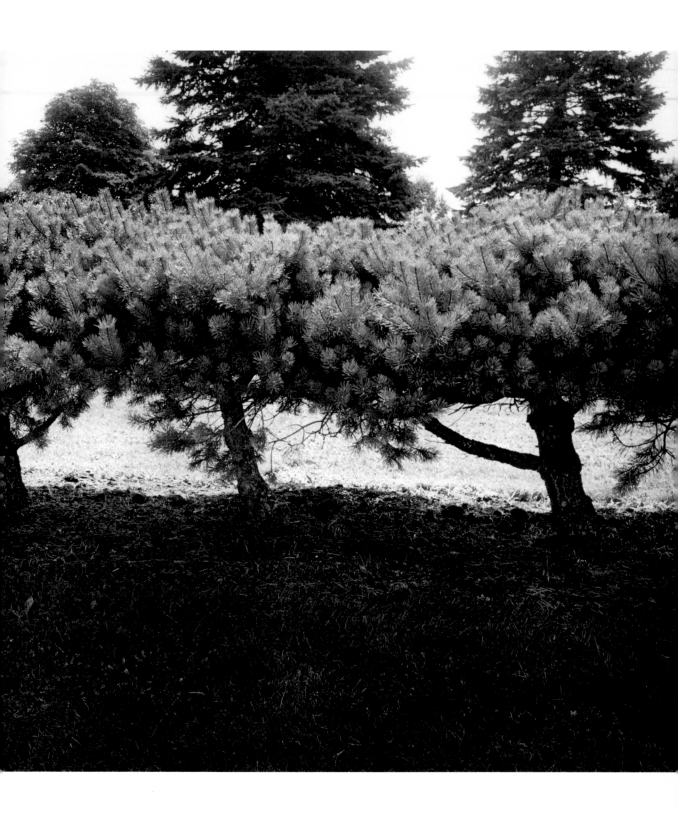

THE QUESTION

The persimmon tree
heavy now
with dusty fruit.

Which
is sweeter?
That going? Or
that gone?

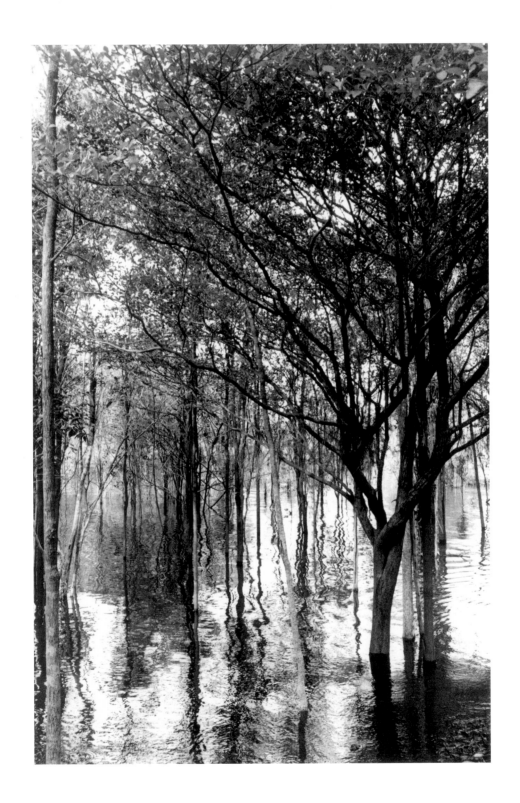

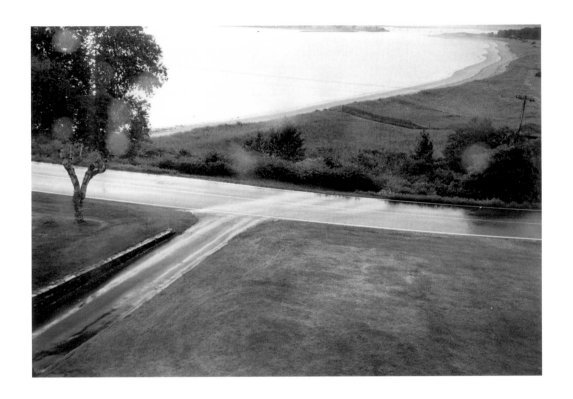

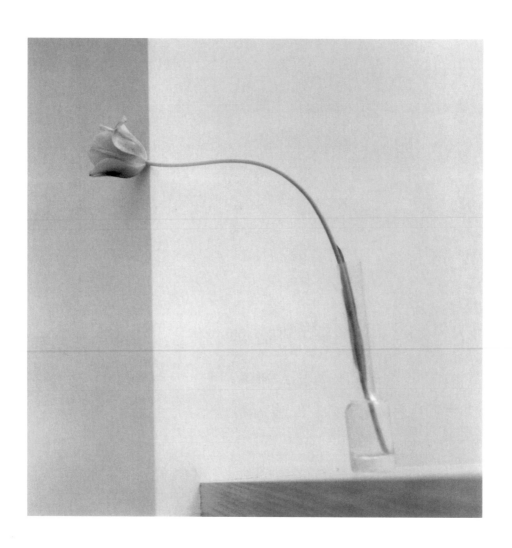

AFTERWORD

BY CLAIRE YAFFA

The edge of light.

It has always been there,

filling me with warmth and radiance,

compelling me toward beauty.

I reach for the other side, fearing the abyss.

Watching, waiting until shadow and light meet,

feeling myself inside them,

unsure of where I am suppose to be.

Do I dwell in one more than the other?

A deeper look usually assures my presence

adrift somewhere within the transformation.

I am not always as I take myself to be or

how I appear to others.

But, now I am more than before, without fear,

and light and shadow go on,

flickering, disappearing, until

only the image remains.

LIST OF PLATES

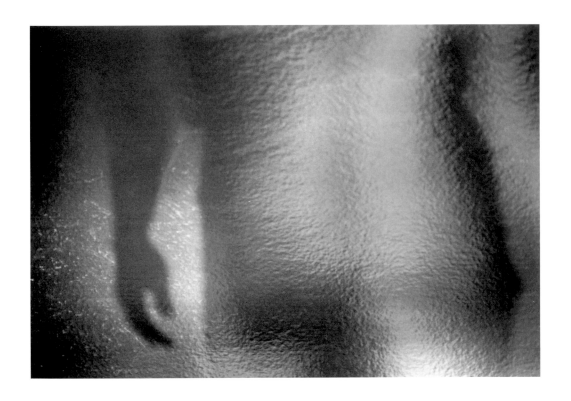

BIOGRAPHIES

CLAIRE YAFFA is a noted freelance photographer who works for the *New York Times*. Her photographs have been published with Condé Nast and Gannett papers, among others. Her photographs portraying child abuse, the homeless, children with AIDS, and the aging population have appeared as part of television documentary reports on NBC, ABC, and PBS. She has published two monographs of her reportage work, *Reaching Out*, and *A Dying Child is Born: The Story of Tracy*. The recipient of the 1995 Westchester Arts Council award, her work has been exhibited throughout the United States, including the Hudson River Museum, the International Center of Photography, Sarah Lawrence College, the White Plains Museum Gallery, and the United Nations.

Yaffa has served as photography editor of *Of Westchester* magazine and photography coordinator of the United Nations Women's Arts Festival. The mother of two children, she and her husband currently reside in Westchester, New York.

GORDON PARKS began his career in photography working for the Farm Security Administration and has continued as an esteemed photojournalist ever since—documenting the civil rights movement, exploring issues surrounding crime, poverty, and discrimination worldwide, as well as producing portrait studies of many notables. Parks worked at *Vogue* and at *Life* as a photojournalist and fashion photographer. His recent art combines painting and photography in a reflective study of form and color. Parks is the author of many works of fiction, nonfiction, and poetry. He has written and directed several motion pictures, including *The Learning Tree* and *Shaft*, and composed a ballet. Now eighty-four, he lives and works in New York City.

JEFFERY BEAM has published widely in small magazines and anthologies, including: *The Son of the Male Muse, Black Men/White Men, The Worcester Review, Smithsonian, Lambda Book Report, Harvard Gay and Lesbian Review*, and *Yellow Silk*. Additionally, Beam is the author of eight books of poems and is the poetry editor of *Oyster Boy Review*. He and his poetry are the subject of North Carolina filmmaker Tom Whitesides's experimental film, *PoemBeam*. Beam lives in Chapel Hill and works in the Botany Library at the University of North Carolina.